W9-CHM-627

Kodak
Pocket Guide to
Great Picture Taking

by the Editors of
Eastman Kodak Company

Simon and Schuster / New York

Published by Simon and Schuster
A Division of Simon and Schuster, Inc.
Simon & Schuster Building
Rockefeller Center
1230 Avenue of the Americas
New York, New York 10020

SIMON and SCHUSTER and colophon are registered trademarks of
Simon & Schuster, Inc.

Library of Congress Cataloging in Publication Data
Main entry under title:

Kodak pocket guide to great picture taking.

 Includes index.
 1. Photography—Handbooks, manuals etc.
 I Eastman Kodak Company.
TR150.K64 1984 778'.28 84-10683
ISBN 0-671-54137-4

Manufactured in the United States of America

1 2 3 4 5 6 7 8 9 10

Eastman Kodak Company, Author
Text written for Kodak by Hubert C. Birnbaum

Editorial Coordination, Derek Doeffinger (Kodak)
Editor, Susan Victor (S&S)
Designed by Dan Malczewski (Kodak)
Production, Charles Styles (Kodak)
 Howard M. Goldstein (S&S)

Photo Credits: p. 31: Bob Taylor; top p. 33: The Bettmann Archive;
bottom p. 85 & p. 87: R. Hamilton Smith; top p. 95: Ric
Ergenbright; p. 53, p.70, bottom p.97: Gernsheim Collection, Harry
Ransom Humanities Research Center, The University of Texas at
Austin; p. 67, Science Museum (London).

The Kodak materials described in this publication for use with
cameras are available from those dealers normally supplying
Kodak products. Other materials may be used, but equivalent
results may not be obtained.

CONTENTS

INTRODUCTION

You may shrug off as a marketing cliché the notion that pictures preserve memories. But when you begin to think about all the pictures you take, of family, of friends, of once-in-a-lifetime trips, and when you leaf through your photo albums recalling those events, it becomes apparent that the strongest memories of your life are often held by the pictures. By making better pictures, you reinforce the feelings that accompanied those moments.

There are two steps to getting better pictures. The first is achieving technical goals, such as good exposure and focus. Nowadays, the camera takes over many of these chores, leaving you to concentrate on the second step—taking the picture.

This book focuses on taking the picture. If you use just a few of the ten tips presented in the first few pages of this book, you'll notice a marked improvement in your results. And if you use many of the other tips in this book, your pictures should improve by leaps and bounds. The other tips show how to photograph specific subjects, such as people, action, and outdoor scenes. They point out the things in the scene, such as lines and patterns, that grab the eye and inspire the viewer.

Give the tips a try. They work. And when you leaf through your pictures should you find yourself admiring the photograph more than the subject it contains, you'll know you've done the job well.

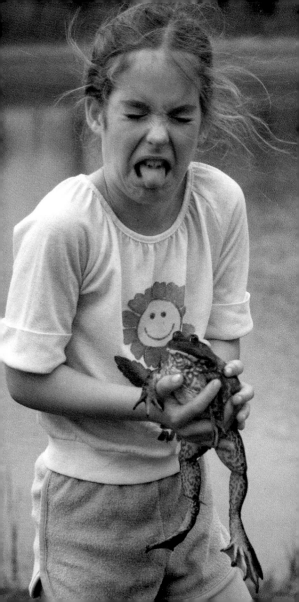

THE SIMPLE CAMERA SYNDROME

Many people who buy simple cameras are more interested in obtaining good pictures than they are in the taking of the pictures. When they discover that their cameras cannot produce masterpieces without some help, they may begin to wonder about the capability of the camera. If you have any doubts as to how well a simple camera can perform, the pictures on these two pages should help you overcome them. These pictures were taken with KODAK Disc Cameras.

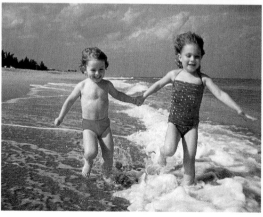

Although you need a reliable camera, whether it's a "professional" 35 mm SLR or a hand-me-down KODAK BROWNIE Camera matters not so much as the person behind the camera. So don't feel that you shouldn't strive to take good pictures just because you don't carry the most expensive camera around. And even if you have the latest and most expensive camera around, remember that it's not the camera but the photographer who takes the picture.

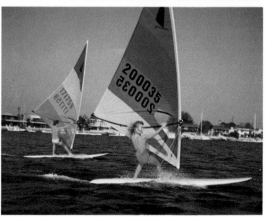

TEN TIPS FOR BETTER PICTURES

Taking pictures with automatic cameras is so effortless that users are sometimes lulled into critical torpor by point-and-shoot simplicity. That's a pity, because one of the bonuses of automated photography is the freedom to ignore camera functions and to concentrate on the subject.

The ten key photo tips introduced here and discussed on following pages comprise a useful checklist to review when making photographs. Most are suggestions rather than iron-clad rules. Simply keep them in mind. They strengthen pictures when used appropriately.

Show one subject clearly

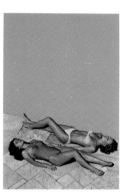

Simplify the background

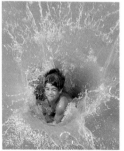

Try a different viewpoint

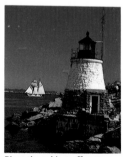

Place the subject off center

Take charge

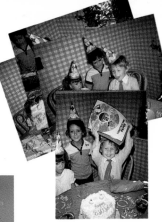

Take extra pictures

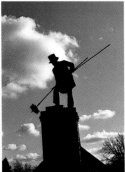

Vary your subjects

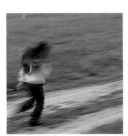

Experiment

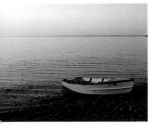

Watch the light on your subject

Get close

Show One Subject Clearly

Photographs, unlike stews, generally become weaker as you add ingredients. A picture with a single dominant subject is likely to be strong. It will make its point quickly and effectively. The viewer will not wonder what to look at first or why you made the photograph.

To make sure the viewer knows what the subject is, you may have to use a few of the other tips in this section. For instance, you can move in close and fill the picture with the main subject or choose a simple background so there's no mistake what the subject is.

Fortunately, the concept of a single subject does not restrict you to photographing the world one person or one object at a time. A single subject can, and often does, comprise multiple related elements. A couple walking hand in hand can form a single subject photographically. So can a stand of trees or a herd of wildebeests. Viewer confusion is almost sure to result, however, should you cram the couple, the trees and the wildebeests within the borders of a single picture.

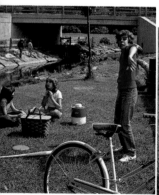

TOO MANY SUBJECTS

ONE SUBJECT

Get Close

A subject large enough to dominate the picture area attracts and holds the viewer's eye. Through image size alone it can overpower extraneous elements within the frame that might otherwise compete for attention. When taking pictures, however, many photographers concentrate so hard on their intended subject that it seems larger in the viewfinder than it really is.

The solution is to take several pictures, each from a closer distance, to ensure that some will show the subject boldly and with minimal surrounding clutter. With practice, you'll develop a sense of how close is close enough.

NOT CLOSE

CLOSE

HOW CLOSE?

If uncertain of the closest focusing distance for your camera, look at the camera front where the closest focusing distance is often printed. If the distance isn't there, consult your camera manual.

For fixed-focus and autofocus cameras, the closest focusing distance is often roughly 4 ft (1.2 m).

For cameras with a built-in close-up lens, closest focusing distance is often slightly under 2 ft (0.6 m).

Check your camera manual to see if your camera requires that you frame the subject differently in the viewfinder when photographing at close distances.

Simplify the Background

Cluttered backgrounds weaken pictures. At best, a busy background competes with the subject for the viewer's attention. At worst, it can falsify the subject's appearance. People don't walk about in real life with tree branches or telephone poles sprouting from their heads. Yet all too often they end up with such dubious embellishments in pictures.

The problem is easy to avoid. Deliberately look past the subject before you take the picture. If the background appears jumbled or includes prominent features that will detract from the subject, change the camera position, subject position or both until you see the subject against a less obtrusive field.

Outdoors you may be able to use the sky as a noncompeting background simply by positioning the camera lower than usual and photographing at an upward angle. This won't work with all subjects, but it works often enough to keep in mind. No matter how you do it, subduing unruly backgrounds will improve your pictures markedly.

BUSY BACKGROUND

PLAIN BACKGROUND

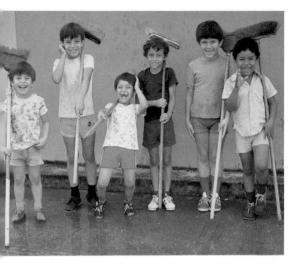

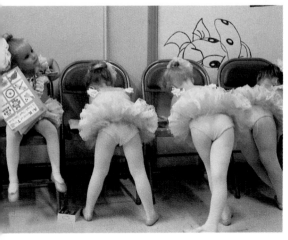

Place the Subject Off Center

When required by visual logic, there's nothing wrong with putting the subject squarely in the center of the frame. But an endless procession of centered subjects can be boring. When framing the scene in the viewfinder, see if you can improve matters by deliberately placing the subject to the left or right of center and a bit higher or lower than usual.

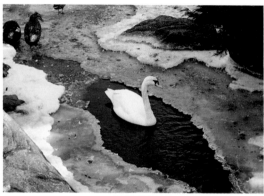

CENTERED

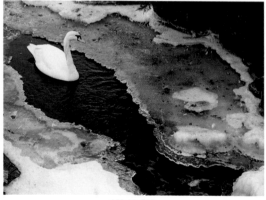

OFF CENTER

Traditional wisdom holds that a centered subject looks static, and that moving it off center creates a livelier picture. Even photographers who disagree with that theory do agree that off-center subject placement is frequently preferable. If you cannot decide which treatment you prefer when framing a picture, shoot several variations. Comparing the finished prints or slides will teach you more about composition in the real world than any amount of theorizing, and you'll be spared the chagrin of looking at a lone picture and wishing you had tried it "the other way."

Try a Different Viewpoint

Most cameras are designed for eye-level photography, and most photographers stand when taking pictures. The result is an unending string of photographs with similar viewpoints. You can add a dash of visual spice to your pictures by selecting unusual points of view. Heroics and acrobatics are normally unnecessary.

Consider what a difference it can make when photographing a child if you just take the picture from his or her eye level rather than your own. Or you might take a strikingly different photograph of a familiar scenic attraction by stretching on the ground for a super-low viewpoint.

If you're energetic, you might climb a tower or a hill for a novel look down at a building or monument. On a purely practical note, you'll be more willing to maneuver into offbeat photographic stances or odd nooks and crannies if you wear comfortable, rugged clothes. Save your finery for social events. In any case, don't overlook the possibility that the conventional viewpoint might be better after all. Take the picture both ways and see for yourself.

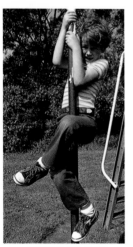

STANDING VIEWPOINT

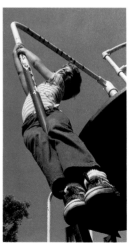

LYING-ON-GROUND VIEWPOINT

18

Vary Your Subjects

It's not unusual for a photographer to photograph similar subjects over and over again. After a while, though, repetition can lead to boredom. One antique car begins to look like another and the castles on the Rhine begin to resemble the castles in Spain. Your interest in the subject matter may be as keen as ever, but you begin to feel as though you're in a photographic rut.

The antidote to the photo-blahs is obvious and pleasant. Find new subjects—fast! Have you had it, at least temporarily, with flower beds? No problem. Switch to the gardeners who tend the beds. Have natural wonders begun to pall? Document your neighbors at work in their yards. Your photographic skills will grow as you meet your expanding needs and interests.

Take Charge

When taking pictures you need not always be passive, you need not accept conditions as you find them. Imagine it's spring: Your daffodils and prized lily-flowered tulips are in full bloom. You could simply wander into the garden and photograph them as they are. Or you could lie beneath them and take pictures of them leaning into the sky, or, you could pick a few, and put them in a vase in a setting that enhances the beauty of the tulips.

Seldom must you accept a scene as you first find it. A little thought and a little action go a long way toward improving pictures.

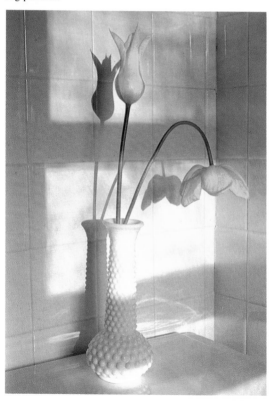

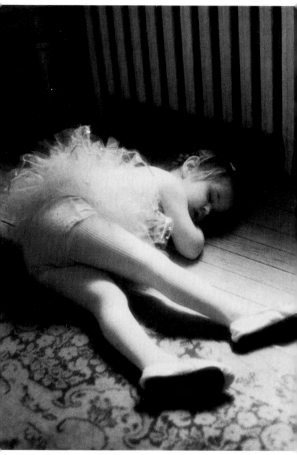

Don't Overlook Opportunity

It's easy to fall into the habit of taking pictures only when you have your camera out for a definite event, such as a family visit. If you have that habit, break it and grab your camera when a sleeping ballerina (above) or any other lucky scene comes your way. You may not get a second chance.

Take Extra Pictures

When you come across a scene that especially appeals to you, take some extra pictures to be sure of obtaining one picture that does justice to the subject. With immobile subjects such as lighthouses, monuments, and cathedrals you can vary the viewpoint. Move around from side to front to back, looking for the best view and appropriate surroundings. For instance, if photographing a conservatory, in one picture you could include the flower garden in front, in another you could show the long walk winding up to the entrance. Instead of just dutifully snapping the picture, try to make each picture the best one.

Even when photographing people, you may need to take several pictures to get the best expression. Expressions and poses shift quickly, and, as everyone knows, eyes blink and if they're caught closed the result can be most unflattering. By taking several pictures of a person, one of them is bound to catch a pleasing expression.

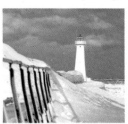
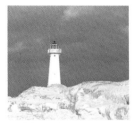
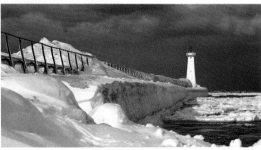

Changing Viewpoint

To makes these pictures of a snowbound lighthouse, the photographer took pictures from several locations trying to find the position that gave the best picture.

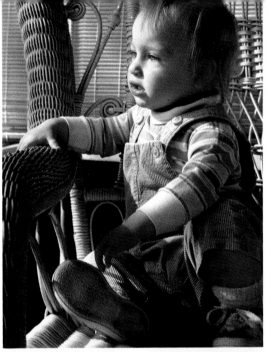

Catching an Expression

A restless toddler squirming in a chair is unlikely to be caught in an ideal pose in the first pic-

ture taken. Several pictures were required to catch the child in a pleasing posture with a good expression.

Watch the Light

A photograph is a record of light reflected toward the camera by the scene. Any change in illumination alters the appearance of the subject and thus the final picture. The intensity of the light, the direction from which it comes, the shadows it casts, its harshness or softness, and its color all bear directly on the picture you make. The more closely you observe the way light affects the appearance of your subjects, the better able you are to make pictures that look the way you want them to look.

Although you cannot always move light sources to suit your purposes, you can often move the subject and/or the camera to achieve more pleasing effects. Is the sunlight too harsh? Move your subject into the shade or wait for a cloud to veil the sun. Is the front of a landmark building too deeply shadowed to show clearly in a photograph? Try again at a time of day when the sun shines on it. Does the subject look pale and colorless? Perhaps the warm orange glow of late afternoon sunlight will add a cheerful touch. Developing an awareness of light and its effect on the subject is a major step toward making pictures that go beyond the ordinary. And all you have to do is observe.

Light Affects Appearance
We all know but pay little heed to how light affects the appearances of things. These two pictures show how greatly light can alter appearance.

Be Alert for Unusual Lighting

Although most of us keep an eye open for an unusual subject—a rainbow, a flaming sunset, a camel ride at the carnival—we tend to overlook unusual lighting. Don't. As these two pictures show, lighting effects can make for good photos.

Experiment

At first, photography may seem bound by a bewildering profusion of rules and instructions and suggestions. In fact, it is a means of expression as free as you care to make it. Most rules can be broken occasionally without dire consequences. They serve as useful guideposts that help you learn the fundamentals of photography. They should certainly not be construed as defining the limits of the medium.

Specific instructions regarding the use of photo equipment and materials, in contrast, should generally be followed precisely to achieve best results. In culinary terms, operate the food processor according to the manufacturer's instructions but feel free to improvise on recipes.

Breaking Rules

Photo tips are not infallible. When instinct tells you to tilt the camera to make a zany picture of the Mad Hatter or to exclude heads of people to concentrate on their limbs, do it. And surprisingly often, you will produce a picture that delights the eye and is uniquely yours. Even if you don't produce a terrific picture, you will learn something about photography that you can put to good use later on.

A World of Whimsy

Whether vacationing or exploring the neighborhood, you come across many strange and amusing sights that can make good pictures. So why not begin documenting the sights that amuse you?

Traditional Subjects

People have long taken pictures of things important to them. For most of us, other people have been more important than anything else and thus, people have been favorite subjects. And often it is the important times in people's lives that we photograph: birthdays, anniversaries, holidays, weddings, and so on. Other favorite subjects since the beginning of photography have been places visited, pets, and possessions. To all these things we have emotional ties and wish to be reminded of them through pictures.

But don't unnecessarily limit yourself. Many a photo album could use a change of pace through a change in subject matter. The next few pages will show that many untraditional subjects can also make good pictures.

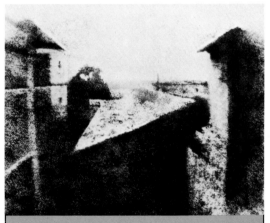

THE FIRST PHOTOGRAPH

The subject of the first successful photograph was rooftops in Gras, France. In 1826 Joseph Nicéphore Niépce was trying to invent a way of recording images photographically. His "film" consisted of asphalt coated on a pewter plate. He chose rooftops because they were visible from his window and because they would not move during the 8 hours of exposure required to record the image.

Places

People have always been interested in seeing pictures of the places they've been as well as the places they haven't been. And don't neglect your own neighborhood, street, backyard or living room. A close look at a familiar setting may disclose picture opportunities you've overlooked. A sight you take for granted may be very interesting to someone who hasn't seen it before.

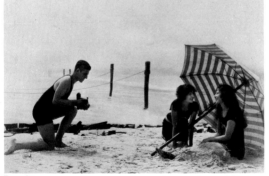

People

From cradle to rocking chair, every stage of life offers more picture possibilities than any one photographer could hope to capture on film. Subjects involving people are as varied as life itself.

Finding New Things to Photograph

Have you ever photographed an eggbeater? A pepper? A trash barrel? Of course not. Yet some famous photographs are of these very subjects. To those of us who dig out the camera only for birthdays and trips, finding new things to photograph can be quite frustrating. It need not be.

Given the right conditions, virtually anything can be made into an outstanding photograph. Merely look around you. See how the tomatoes and pears on a windowsill make a beautiful still life. See how the fence down the road is bejeweled with dew in the morning.

And if somebody makes a wisecrack as you photograph the broom leaning against the drainpipe, simply smile indulgently and revel in your bit of eccentricity.

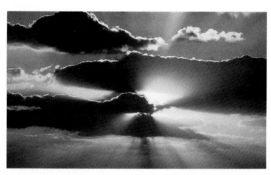

You and Your World

The uniqueness of your personal vision is what sets your photographs apart from others. Only you can bring your tastes and interests to bear on the subjects you choose, and your choice of subjects should reflect your personality. When you show someone a picture you have taken, you are in a sense lending that person your eyes. You are allowing, in fact compelling, the viewer to see the subject your way.

Give in to your photographic tastes and photograph the things that stir your feelings. That you care about the subject nearly always improves a picture.

Some of the most powerful photographs ever made have been motivated by the photographers' need to show evil and injustice in the hope they would be remedied or to show natural beauty and majesty in the hope they would be preserved.

Photograph What You Like

Your best pictures, and the ones you'll most enjoy making, will always be those that reflect your interests. Don't feel obliged to make pictures of certain subjects because other people do it all the time. And don't be reluctant to photograph things that other people pass by. The freedom to choose subjects that please you is a precious freedom. Exercise it and enjoy it.

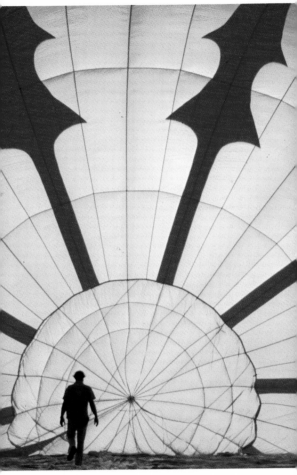

Know Your Subject

Whether you're photographing a football game or a hot-air balloon, the more you know about your subject the better you can reveal it. In making this picture, the photographer knew the balloon would look most colorful with sunlight streaming through it. While the balloon was being inflated, the photographer stepped into its mouth and snapped the picture.

37

EYE GRABBERS

Some pictures trap your gaze and won't let go. Occasionally it's because the content is so unusual that you simply must look. Often, though, more compelling than the subject is the manner of presentation. The strongest pictures combine an arresting subject with bold presentation. You can enhance the impact of the pictures you make by emphasizing graphic elements in the scene. The first step in exploiting them is to recognize them.

Look for well-defined lines, shapes, forms, textures, colors, and patterns. These are the visual elements that grab the viewer's eye. These design elements are such powerful photographic tools that they are discussed individually on the following pages.

LINE

SHAPE

FORM

TEXTURE

COLOR

PATTERN

Line

Prominent lines lead the eye through the picture as surely as railroad tracks guide a train. Lines can be as straight as a flagpole or as curved as a horseshoe. Lines can be real and continuous like a road or implied by a row of pumpkins. You can use a leading line to rivet attention on the subject or to carry the gaze from a near object to a distant one, enhancing the illusion of depth.

Lines can divide the picture into compartments that isolate a subject or emphasize distinctions between separate components. When you spot a linear element in the scene, use it to take the viewer's eye for an unforgettable trip through the photograph.

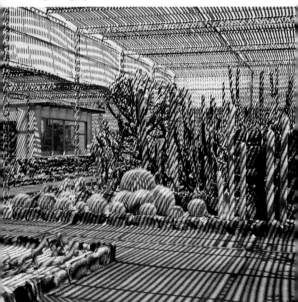

Dynamic Lines

Oblique and curving lines are more dynamic than vertical and horizontal lines. Normally, vertical and horizontal objects, such as fence posts and railroad ties, appear to be stable, thus less dynamic. Oblique lines seem to carry a little of the Tower of Pisa with them in that they could succumb to gravity at any time.

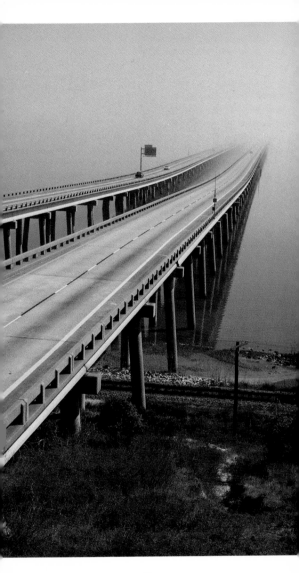

Shape

From birth we learn to pay close attention to shapes in the world around us. The shape, or outline, of a person or object often provides all the information we need for positive identification. Photographs that clearly define subject shapes command attention and reward the viewer with the pleasure of instant recognition. You can emphasize the shape of a sharply focused subject to make it leap out of the photograph.

Find a camera viewpoint that allows the subject to stand out from foreground and background and that discloses a striking or significant subject outline. For example, a face in profile presents a more interesting and identifiable shape than a straight front view. A side view of a sleek sports car symbolizes speed more effectively than a quarter-angle approach.

Many subjects offer a wealth of different, photographically appealing shapes depending on the point of view, so stalk your subject from a variety of angles. You will often find several aspects worth photographing.

Form

Form is the three-dimensional aspect of a subject. A jagged rock outcropping, a cylindrical oil tank, a steamer trunk, an elephant and a drum majorette fill space in distinctively different ways.

One of the challenges in photography is to make a two-dimensional picture that preserves the sense of three-dimensionality you experience looking at the actual subject. Photographs in which subject form is preserved tend to look realistic.

Pictures in which subject form is minimized often look abstract or unnatural. Either type of rendition can be desirable or undesirable, depending on your visual intent.

FRONTLIGHTING
(sun behind you)

SIDELIGHTING
(sun on either side of you)

44

Preserving Form

Choose a point of view that shows enough of the subject to define its significant features. For example, a cube will look three-dimensional if you show two or three faces, but will appear to be a flat square if you see only one side. Use light to model the form. The interplay of highlights and shadows differentiates subject planes and contours. As a rule, sidelighting and top lighting reveal form well. Frontlighting (sun behind you) and shadowless lighting (such as on a cloudy day) tend to make subjects look relatively flat.

Texture

A picture that makes us feel the roughness of a tree trunk, the smoothness of polished marble, or the weave of tapestry plays to one of our strongest instincts: the desire to experience by touching. With texture revealed, the object actually seems to exist within the photograph.

Use three basic strategies for revealing texture dramatically in a photograph: Get close enough to record surface detail clearly; make the sharpest picture you can; and try to make the picture with light skimming the surface of the subject. If you're too far from the subject, surface details such as the small peaks and depressions of a stucco wall or the character lines in a craggy face will be too small on film to show clearly.

The larger the details are on film, the more strongly the picture can convey the subject's texture. A sharp image reveals texture better than an unsharp one because it preserves vital surface detail. And skimming light enhances texture in a photograph because it throws even small surface features into bold relief, exaggerating them visually.

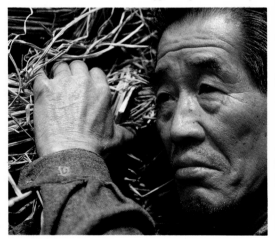

Rugged Texture
In this picture, sidelighting stresses the wrinkles of the man's face and his gnarled hands. The use of texture creates a rugged portrait that reflects the man's harsh life. The photographer moved in close so that texture would be clearly revealed.

Fine-Grain Film Best for Texture

Fine-grain films, such as KODACOLOR VR 100 and VR 200 can best hold the details found in texture. If taking several texture pictures or planning on sizable enlargements, use either of these films.

Color

Colors can evoke moods and trigger emotions. Expressions such as "feeling blue," "seeing red," and "turning green with envy" readily reveal that we associate mood with color. Additionally, we simply find colors and their combinations attractive or unattractive. Who hasn't involuntarily cringed when spotting somebody wearing a fluorescent green shirt with "hunting" orange pants? By photographing subjects with powerful (though not necessarily bright) colors, you can make your photographs more stimulating.

Warm colors, such as orange and red, suggest heat, passion, and excitement. They jump boldly at the viewer and demand attention. Cool colors, such as blues and greens, suggest coldness and tend to calm rather than excite. They are often perceived as receding and distant. Even when preserved in photographs, the ruddy glow of a wood fire and the frigid blue of an ice cavern retain their ability to heat and to chill.

Less Color Can Be More
Subjects with few or quiet colors often move the viewer more than colorful subjects. Scenes with little color often seem tranquil or sad.

48

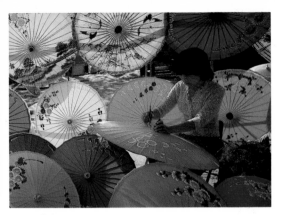

Bright Colors

Bright colors catch the eye. It's impossible to ignore a red barn in a green field or an array of colorful umbrellas. Bright colors stand out best when seen against a muted background. KODACOLOR VR 200 Film is a good choice to capture a variety of bright colors.

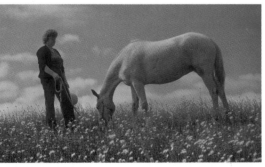

Manipulating Color

You can add washes of color to your pictures by fastening a colored filter to your lens or simply holding the filter or a piece of colored plastic in front of the lens. Seashores draped in blue, sunsets inflamed with orange: the choice is yours. When you want unusual color effects, use slide film if possible. When making color prints from negatives, photofinishers try to deliver a print with conventionally correct color values, unless you specify otherwise.

Pattern

A pattern is to a photograph what a driving beat is to a piece of music. Simple repetition of shape or form is a powerful photographic device. Be alert to patterns you can exploit, either as design elements that enhance the main subject or as principal subjects. You can use a picket fence to take the eye on a rough ride toward the subject, or you can relish its staccato rhythm for its own sake.

Patterns, both natural and manmade, are so common that we often don't notice them. You might say it's a case of not seeing the trees for the forest. Look for patterns wherever you go, and collect them on film. From the stately cadence of trees guarding a country lane to the intricate filigree of a fire escape and its shadow on a city wall, it's difficult to imagine a pattern that cannot inspire a striking photograph.

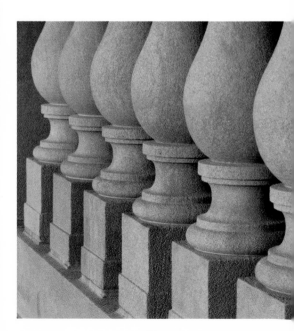

Composition

Composition is visual organization. It includes but is not limited to the placement of subject matter within the frame and the resulting interrelationships. The reason for composing carefully is to emphasize the principal subject and to subordinate any secondary elements in the picture.

A well-composed photograph looks harmonious even when it contains numerous elements. Poorly composed pictures look awkward even when they contain few components. Important compositional controls include the choice of vertical or horizontal framing, camera viewpoint, subject placement, contrasts, and isolating details.

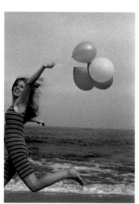

Vertical and Horizontal Framing

Most cameras make rectangular pictures. Subjects that are strongly vertical or horizontal will fit most comfortably within the frame when you orient the camera so that the long dimension of the frame parallels the long dimension of the subject. The Empire State Building demands a vertical frame. A sprawling ranch house fits naturally into a horizontal photograph. When a subject looks good framed horizontally or vertically, photograph it both ways and decide later which version you prefer.

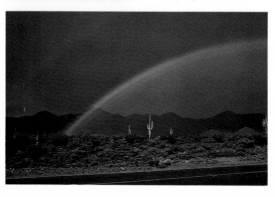

Subject Placement

An important decision in composing the picture is where to place the subject within the frame. As noted earlier, the center is often not the best place because it may make the picture look too static. Action pictures in particular may benefit from unusually high, low,

left or right subject placement. As a rule, it's advisable to leave extra space ahead of a moving subject to avoid creating the claustrophobic feeling that it is about to crash into the edge of the frame. When time permits, shoot several variations of interesting subjects.

Contrast

Contrasting elements add interest to photographs and can be used as compositional building blocks. Almost any kind of contrast you can conceive helps structure a photograph. Contrasts of tone, color, sharpness, size, and subject are all fair game. Juxtaposing subjects of very different character is sure to amuse or amaze.

Tonal Contrast

Contrasting areas of light and dark work powerfully in color and in black-and-white pictures. Like a spotlighted performer on a dark stage, the subject is shown clearly if it is lighter or darker than the background. The eye tends to look first at the lightest areas in a picture, so try to avoid including prominent irrelevant highlights.

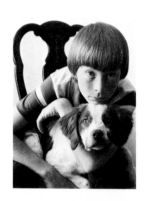

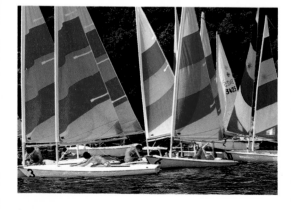

Color Contrast

An area of bold color against a contrasting or neutral field is a guaranteed attention-getter. You cannot miss the bold colors in a fleet of sailboats.

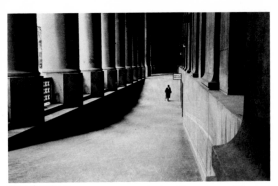

Size Contrast

Including an object of known size in a photograph can increase the impact by lending scale to other objects, especially when there is a great disparity in size. The vastness of the ocean is more apparent in contrast with a lone small boat, just as stone columns seem to tower higher when compared with a small figure.

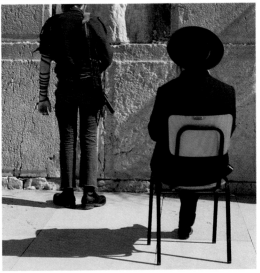

Character Contrasts

These two men appear as opposites but share a common bond in prayer at the Wailing Wall in Jerusalem.

Significant Detail

Sometimes concentrating on an isolated detail makes for a stronger picture than a broad view. The latter may contain such a welter of information that the viewer doesn't know where to look first. When faced with a subject too large or complex to show compellingly in an overall view, select one or more significant details to show in individual pictures, each of which stands for the whole. For example, a broad view of a carefully tended formal garden may look pretty but unspectacular compared with a closer view of topiary hedges trimmed into imaginative shapes.

If your camera has a close-up setting or a lens that can be focused on a close distance, consider making tightly cropped close-ups of story-telling details. Dramatically large images of small subjects are always attention-getters.

Isolating details is also a picture-saver when an interesting subject is situated in a nonphotogenic setting. A vintage car on display at an auto show may be hemmed in by other vehicles that form a cluttered, distracting background. Nonetheless, you may be able to make fine detail views of features such as the hood ornament, a distinctive radiator grille or gleaming wire wheels.

LIGHTING

A photograph is a record of the light the subject reflects toward the camera. Therefore, the nature of the light illuminating the subject determines the appearance of the picture. It is ironic that we pay so much attention to the subject and so little to the lighting. Important lighting variables you should be aware of and use to your advantage include direction, color, hardness, and softness. Using light to silhouette your subject is a dramatic technique worth trying.

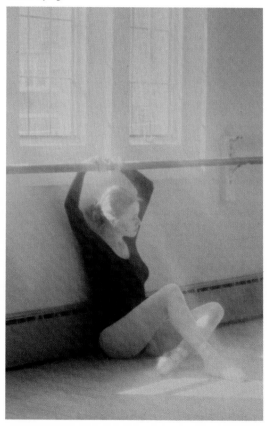

Direction of Light

Sunlight changes direction constantly as the sun traverses the sky. With fixed subjects, such as monuments and mountain ranges, wait until the sun reaches a position that provides favorable illumination. With movable subjects, you can usually obtain desirable lighting effects by changing subject and camera positions relative to the light source.

Frontlighting

Frontlighting is even and casts shadows behind subjects, where they interfere least with the picture. Because it is so even, frontlighting tends to be somewhat flat, and is not the best choice for revealing form and texture.

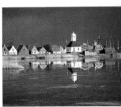

Sidelighting

Sidelighting fully illuminates the side of the subject facing the light source, but leaves the rest in shadow. It is a bold light that emphasizes or exaggerates form and texture. If your camera permits you to influence the exposure, try adding about a half-stop more than the meter recommends when photographing a sidelighted subject with significant shadow detail.

Backlighting

With backlighting, the light source is behind the subject. It separates subjects from their surroundings with a rim of light. Long shadows advancing toward the camera can create a strong illusion of depth in outdoor scenes. Additional exposure or supplementary flash illumination may be necessary to hold important shadow detail in nearby subjects (see your camera manual for specific procedures, if applicable).

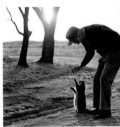

Hard and Soft Light

The bright sun in a cloudless sky, a stage spotlight and a high-intensity reading lamp all produce hard light. Hard light is direct and harsh. It creates sparkling highlights and intense, clearly defined shadows. It reveals texture, but surface glare can sometimes weaken, or desaturate, colors. Hard light can create dancing highlights on water as well as masses of inky shadows that dramatize sculptural or architectural forms. It can be unflattering for conventional portraits because it mercilessly reveals complexion flaws and makes people squint.

Soft light is indirect and diffused. The nearly shadowless, nondirectional light of an overcast sky is an example of soft, diffused lighting. It envelops the subject and creates gentle highlights and shadows that do not call attention to themselves. Soft, diffused light gently models forms, tends to suppress surface texture and allows subject colors to record strongly. It is very flattering to people.

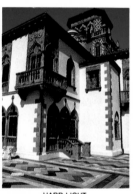

HARD LIGHT

SOFT LIGHT

Hard vs. Soft Light
In these comparison pictures, the hard light of direct sunlight creates deep shadows that define the angles and features of the building. With soft light from an overcast sky, the buildings's shape is not so obvious. Note the color shift caused by the different lighting.

60

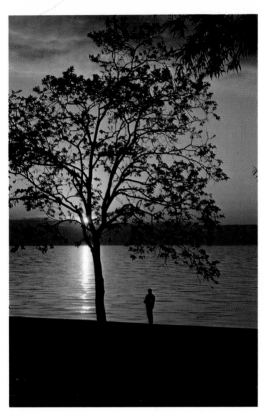

Silhouettes

Silhouettes are high-impact pictures that suggest the subject by emphasizing shape rather than form. The basic ingredients of a silhouette are a subject that is shadowed on the side facing the camera and a much brighter background. Most automatic cameras expose such scenes satisfactorily as silhouettes, recording the subject in suitably dark tones. If your camera has a built-in flash unit, check to make sure it is off. If you cannot control the flash manually, cover the flash window with a free finger or two, or some swatches of black tape. Subjects with distinctive outlines are the best candidates for silhouette treatment.

Taking Pictures in Dim Light

Most of us were raised in the photographic tradition of taking pictures outdoors on bright days or indoors with flash. When a cloud slipped over the sun or the sun dipped below the horizon, we packed the camera away for another day. That tradition was based on films that required a lot of light to make pictures and the avoidance of cumbersome flash units difficult to operate.

That tradition is crumbling. With the advent of faster films, you can now take pictures easily in dim light (often called existing light). If you still shoot only on sunny days, now's the time to make the change. Load some KODACOLOR VR 400 or 1000 Film in your camera and venture into the twilight or explore the dim environs of your home.

In Dim Light with KODAK Disc Cameras

How dim must the light be before your KODAK Disc Camera won't be able to take a picture? That's sort of a trick question because the KODAK Disc Camera turns on its flash automatically so you can take pictures of nearby subjects even in the dark.

So let's say the subject is too far away to be lit by the flash.

Then you can probably get good pictures of a skyline or sky until ten minutes after the sun sets. You can take pictures of night sports in brightly lit stadiums, of **brightly** lit stage shows and basketball games, of neon signs, ice shows, and circuses. Brightly lighted streets and darker scenes are borderline but worth trying if you want a picture.

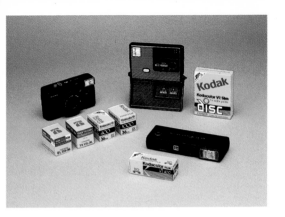

Films for Dim-Light Photography

If you have a 35 mm camera, you can choose from several films:

Color prints: KODACOLOR VR 400 or VR 1000 Film

Color slides: KODAK EKTACHROME 400 Film

Black-and-white prints: KODAK TRI-X Pan Film

If you have a 110 camera, use KODACOLOR VR 400 Film (color prints).

If you have a 126 camera, use KODAK EKTACHROME 200 Film (color slides).

If you have a disc camera, use KODACOLOR VR Disc Film

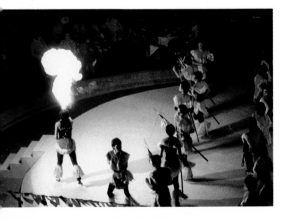

FLASH PICTURES

Battery-powered electronic flash units built into, or available as accessories for many basic cameras, let you take pictures with ease when existing light is too low. Whether in a dim cathedral, a brightly-lighted dining room, or outside in the pitch black of Halloween, your flash unit will give light for clear, sharp pictures. Some cameras, such as KODAK Disc Cameras, automatically turn on and fire the flash in dim light, freeing you from having to remember when to turn on the flash.

Your flash unit will perform best with fresh batteries, so take a spare set with you when you expect to make flash pictures. Wait until the flash-ready signal indicates that the unit has stored sufficient power for proper exposure. Take care that your fingers or the flap of the camera case remain clear of the window; if they block it, underexposure will result.

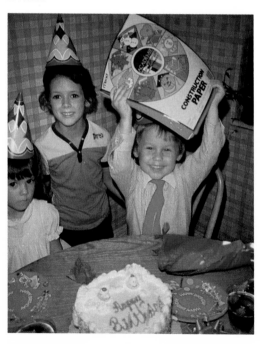

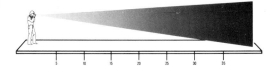

Flash Range

Have you ever seen the twinkle of camera flashes during ceremonies at the Rose Bowl or other night events? Well those flashes won't do any good—the action is too far away. A built-in flash seldom can light subjects beyond 20 feet (6 m). See the flash or camera instruction manual to find the distance range for your unit.

By using KODACOLOR VR 400, KODACOLOR VR 1000, EKTACHROME 400, and TRI-X Pan Films you can stretch flash range appreciably. These films need less light to make good pictures.

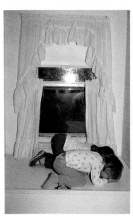

REFLECTION WHEN HEAD-ON

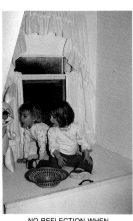

NO REFLECTION WHEN AT AN ANGLE

Watch Out for Reflections

Keep an eye out for shiny surfaces near or behind your subject when you're taking flash pictures. They can pick up the burst of light from the flash and turn it into a flaring blotch in the photograph. The best solution is to find a less reflective setting for the picture. If you must stay in the area, compose the picture so you can shoot at a sufficiently oblique angle to problem surfaces to avoid photographing a direct reflection of the flash. Another way to dodge the issue is to position the subject squarely between the flash and the reflective surface, thus blocking the reflection.

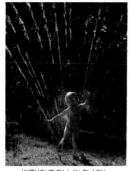

WITHOUT FILL-IN FLASH

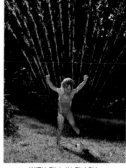

WITH FILL-IN FLASH

Fill Flash

When outdoors on sunny days, you can use flash to restore detail and pleasing color rendition in backlighted portraits, or to achieve a better exposure balance between a subject in the shade and a fully lighted background. The technique, called fill or fill-in flash, consists of directing flash illumination at the subject.

With some cameras you may have to trick the flash unit into firing in bright light by covering the light-measuring cell on the front of the camera. Otherwise, simply turn on the flash and take the picture. Usually the lighting will look best if pictures are taken from a 7 to 13-ft. (2 to 4 m) range. If experience indicates that less light from the flash is preferable, increase the shooting distance slightly or drape a single layer of a clean white handkerchief or facial tissue over the flash window to attenuate the light. If you want more fill light, move a little closer.

FILL-IN FLASH PICTURE TAKEN WITH DISC CAMERA

Built-in Flash Orientation

Cameras with built-in flash units, such as KODAK TRIMPRINT and KODAMATIC™ Instant Cameras and KODAK Disc Cameras, are often designed with the flash window at one corner of the camera body. When you hold such a camera, be sure that the flash window is above rather than below the lens if you're taking flash pictures. This is important when photographing people at close distances. If the flash window is below the lens, it may cause an upside down lighting effect that can be disturbing even when it is subtle. It causes a person's nose to cast a shadow

upward in a manner reminiscent of the "monster lighting" used in horror movies. Keep the flash window above the lens except on Halloween.

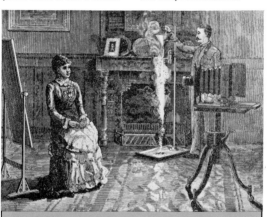

EARLY FLASH PHOTOGRAPHY

Although many of us remember the flash bulbs which we stuck into a reflector on top of the camera, few are familiar with flash lighting of the late 1800's. It consisted of dispersing a handful of magnesium flash powder in front of a flame which ignited the powder to produce a brilliant flare (and dense clouds of white smoke). Typically used was a device that used an air bulb to direct the powder at a candle, behind which was a reflector to shine the light back at the subject. In this illustration, the photographer is dropping the powder into a funnel that directs the powder past a flame.

PEOPLE PICTURES

People are the most popular subjects. From the newborn to the senior citizen, under your own roof or half a world away, the variety people offer is a source for boundless exploration. And there are probably as many ways to photograph people as there are people to photograph.

On the following pages, we present several of the most important techniques you can use to get better pictures of people. The techniques are surprisingly simple. With just a little practice, you should soon notice an improvement in your people pictures. With whom should you begin practicing? Why with those who have gladly been the subjects of your camera all these years—your family. Once you are confident in photographing your family, branch out to others.

Relax Your Subject

When taking pictures of people, getting them to relax may be your most important goal. In front of a camera, people often stiffen and become self-conscious, and nothing ruins a picture quicker than a subject who looks like he'd rather clean out the attic than get his picture taken.

You can put subjects at ease with conversation. Tell them how good they look and how well they're going to photograph. Discuss a topic in which they are interested. Ask questions about what they're doing. And all the while, keep photographing. Above all, be prepared to take pictures quickly and decisively as soon as your subject is on camera. A fumbling photographer makes a subject edgy.

To Pose or not to Pose

Posing a subject ensures that he or she will be shown to best advantage in a photograph. Not posing a subject, taking a candid picture, may better reveal the character and personality of the subject. Which to do? In part, the decision should be based on what you expect from the picture, on how it will be used. If you want to capture a flattering physical likeness to place on the mantel, then take a portrait. If you want to catch the joviality of Uncle Harry, then a candid shot of him in action might be better.

THE POSING CHAIR

In the 1880's people sitting for a portrait were often asked to sit in a posing chair whose straps and supports would hold the sitter immobile. Back then, the film required several minutes of exposure. If the person moved during the exposure, the picture would be blurred. Since few people could sit perfectly still for several minutes, their immobility was enforced by the rigid posing chair.

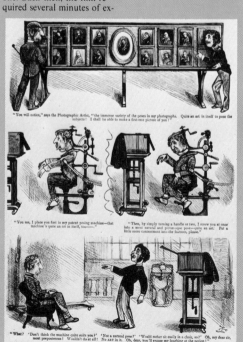

"You will notice," says the Photographic Artist, "the immense variety of the poses in my photographs. Quite an art in itself to pose the subjects! I shall be able to make a first-rate picture of you!"

"You see, I place you first in my patent posing machine—that machine's quite an art in itself, too—"

"Then, by simply turning a handle or two, I screw you at once into a most natural and picture-ripe pose—quite an art. Put a little more contentment into the features, please."

"What? 'Don't think the machine quite suits you?' 'Not a natural pose?' 'Would rather sit easily in a chair, so?' Oh, my dear sir, most preposterous! Wouldn't do at all! No ART in it. Oh, dear, you'll excuse my laughing at the notion!"

POSED SHOT

CANDID SHOT

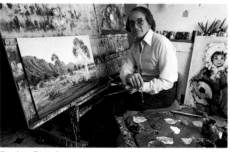

Posing People

When posing a subject, you position him or her favorably in relation to the setting and see that the various parts of the body are arranged pleasingly. If posing a group, don't just line them up, but arrange them in a balanced and pleasing manner as in the top picture on this page. Select surroundings that don't compete with the subject, or, alternatively, that do provide pertinent information about the person. For example, a man who loves painting might be photographed at

his easel or with some of his works. Pay attention to the appearance of hands, feet, arms, and legs. When you suggest a change, be positive, specific, and encouraging. Don't say, "That doesn't look good, move your foot." Tell your subject instead, "You're going to look great if you just bring your right foot about five inches straight back." Finally, don't overdirect. Many people will naturally assume pleasing poses in response to the setting or situation. When they do, leave well enough alone.

72

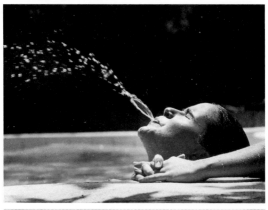

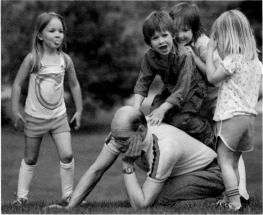

Candid Photography

In candid photography, the subject is either unaware of or unconcerned with the presence of the camera, and the photographer exercises no direct control over events. Candid photographs are marked by spontaneity and often look journalistic. Good candid technique entails photographing quickly and unobtrusively.

Automatic cameras that don't require much adjusting are an advantage. Try to spot picture possibilities far enough in advance so you can move directly to a good vantage point and begin photographing at once. Although candid photography is unobtrusive, it should not be sneaky. If people indicate that they would rather not be photographed, respect their wishes.

Portraits and Full-Length Views

A portrait consisting of a frame-filling face or head-and-shoulders view evokes a feeling of closeness and intimacy. Such close looks concentrate attention on the subject dramatically. Focus on the eyes. If they are sharp, the picture will be perceived as sharp, even if nearer and farther features are visibly out of focus. However, be careful not to get too close or you risk caricaturing facial features through exaggerated perspective. Even if your camera can focus closer, it's a good idea not to approach nearer than about 3.5 ft (1.1 m).

Full-length or three-quarter-length pictures are less intimate but can tell the viewer quite a lot about the subject through posture, clothes, and surroundings. Be selective about what you frame with the subject, and don't back off farther than necessary. You may be able to show a young girl's first prom dress just as well in a three-quarter-length view as in a full-length picture and with fewer distractions.

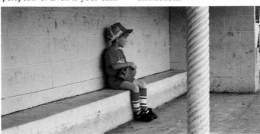

Emotion

The everyday joys and sorrows in life, as well as the extraordinary ones, can be preserved in pictures. The elation of the first-time father, the dejection of Little League losers, and the pride of the valedictorian show in their faces and posture. Have your camera ready to capture fleeting expressions and telling gestures. Because emotion shows strongly in facial expression, move close enough to reveal expressions clearly. Be on the lookout for expressive "body language," whether it's a proud toss of the head or a downcast droop.

Eyes and Hands

Pay attention to the way eyes, hands, and legs will appear in the picture. For maximum impact, as in this picture, have the subject gaze directly into the lens and make strong eye contact with the viewer. If the subject looks anywhere else, make sure there is a good aesthetic or logical reason for doing so. If you include the subject's hands in a portrait, position them gracefully. Hands often look good when oriented with an edge toward the camera. Sometimes hands can be the subject of a portrait by themselves. The strong, callused hands of a farmer or the long, slender hands of a pianist tell different and interesting stories.

Lighting People Outdoors

When you photograph people outdoors, observe the way they look in different light. A person's appearance changes depending on whether light is hard or soft and depending on the direction from which it comes. Hard, direct sunlight can work well when you're not too close to the subject or when you're photographing a group. In close views, though, it's rough on complexions and is too harsh for most faces. One exception: people with rugged faces that have lots of character lines. For these fortunate few, hard lighting works well. The diffused light of open shade or an overcast day is much kinder to most faces. Its soft, wrap-around quality reveals facial form tenderly, without high-lighting blemishes.

DIRECTION OF LIGHT

Straight frontlighting can make faces look a bit flat, but is a safe choice for active subjects because they will be fully lighted wherever they roam in front of the camera. Sidelighting creates drama, but at the cost of shadow detail on the unlighted side of the subject. Toplighting from the overhead sun casts unpleasant shadows in eye sockets, beneath the nose and under the chin. You can sidestep these problems by having the subject tilt his or her head upward until the shadows are sufficiently reduced, then make the photograph from a suitably higher-than-normal viewpoint. Backlighting creates a halo of light separating subject from background, but leaves the side of the subject facing the camera in shadow. It's interesting and instructive to photograph the same subject repeatedly in different light. You will pay much closer attention to lighting effects after doing so.

FRONT LIGHTING

SIDELIGHTING

TOPLIGHTING

BACK-LIGHTING

Lighting People Indoors

By far the easiest way to photograph people indoors is with a built-in or accessory automatic flash unit. The flash is fast enough to stop action crisply and produces attractive color rendition on popular daylight-type color films. If your camera can make exposures at about 1/60 second, has a lens with a maximum aperture in the vicinity of f/2.8 or faster and can accept fast films with ISO speeds of 200 or higher, you can make good indoor people pictures in reasonably bright existing light without using a flash. Place your subject in a chair next to a window without direct sunlight; here the light is bright and creates pleasant results.

TAKEN BY WINDOW LIGHT

TAKEN BY FLASH

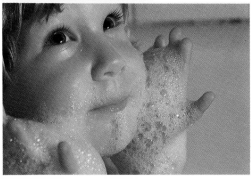

Family Photographs

The most treasured photographs are those of family members, the people nearest and dearest to us. Regardless of artistic merit, pictures of loved ones are cherished.

Although family albums of the past often appeared to contain stiff, formalistic likenesses or quasi-likenesses of children and adults looking vaguely as though they would rather be somewhere else, today's easy-to-use cameras and fast films encourage making family pictures that reflect the spirit and spontaneity of life.

At home, keep handy a camera loaded with fresh film to capture unexpected moments of familial felicity. And be sure to take your camera and an ample supply of film to family gatherings. To paraphrase the well-known travelers' check slogan, don't leave home without them.

Everyday Doings

A few times a year, take pictures of family members involved in daily activities. Show the kids cleaning up their rooms, dad reading the paper, the teenagers on the phone, mom doing the taxes, or whatever reflects the typical daily events of your home. At first, such pictures may not seem worth the trouble but when you view them later, they'll be much more memorable and valued than the occasional posed pictures.

Special Events

Weddings, birthdays, reunions, anniversaries, the ceremonial handing over of car keys Complete the list to suit your lifestyle. These landmark events are natural times for photography. Since many such occasions occur indoors, make sure your flash batteries are up to snuff and have an extra set ready in case you take more pictures than you anticipate. You probably will.

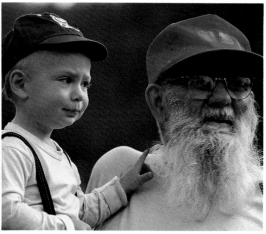

Bridging Generations

The tender relationships between the youngest and oldest members of a family provide especially good photographic opportunities. In any situation that would normally evoke parental pride, grand- or great-grandparental pride will virtually beam out of the picture. Be alert to moments of pleasure shared by the young and the old.

Photographing Children

Childhood is a time of high-spirited, free-form, constant activity, so prepare yourself accordingly. If your camera accepts high-speed films, use them for better action stopping, particularly when the light isn't very bright. A flash unit is almost a necessity for photographing frisky children indoors.

If your subject is constantly on the move, try to anticipate where he or she will go next, and aim at that spot instead of trying to track the kid with the camera. Remember, too, that children are impatient and have short attention spans. Keep photo sessions short enough to avoid boring or irritating them. You'll know when to stop: it will be obvious.

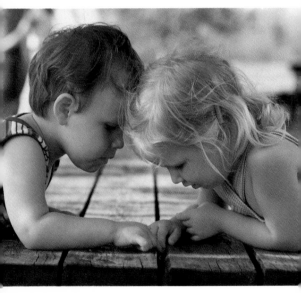

Use Low Viewpoints

Too many pictures of children are made looking down from an adult's eye level. For a more pleasing perspective, position the camera lower, at or near the child'e eye level. And if you'd like to make a small child look ten feet tall on film, place the camera near the ground and aim upward. Don't stand on your adult dignity when you're taking pictures of children. Unbend, enter their world, and enjoy.

Let Kids Be Kids

The most appealing pictures of children show real, animated youngsters, not miniature dandies and debutantes on good behavior and dressed to the nines. If you attempt making formal photographs of young paragons and find the situation coming unstuck, as it surely will, relax, and keep taking pictures. Give your subjects a break and let them be themselves. Your pictures will be better for it.

Youthful Moods

Children's moods change often, quickly and openly. It's fair to say of a child's emotional state, as of the weather in some places, "If you don't like it now, just wait five minutes." It isn't unusual for a child to be withdrawn and introspective, outgoing and gleeful, eager for new experiences, and upset by the unfamiliar in such rapid succession that the adult mind is left far behind. This astonishing volatility is a photographer's delight even when it tries the parental soul. Don't limit photography to periods of sweetness and light. Sulks, tantrums and tears have a legitimate place in the family album, too.

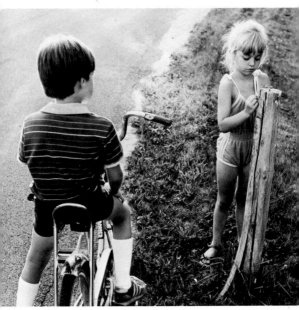

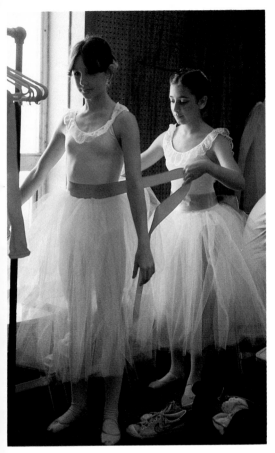

Major Moments

A child's life is full of "firsts." The first haircut, the first day of school, the first dance recital, the first departure for camp, the first date. They are events you'll want to capture in pictures. Often the child will be so involved in the experience that you'll be able to make natural-looking candid photographs without any self-conscious "mugging" for the camera. When a child is overly camera-conscious, be patient. Soon he or she will become immersed in something of greater allure and the natural look will return.

OUTDOOR SCENES

The grandeur of a sweeping vista and the smaller-scale serenity of a bend in the brook can both be taken home and shared in photographs. Find a dominant feature of the landscape and concentrate on it.

Although getting close may seem unnecessary when dealing with subjects as large as the great outdoors, filling the frame with the principal subject is vitally important. The majesty of purple mountains can be lost if they are so small in the picture that they appear to be mere bumps on the horizon.

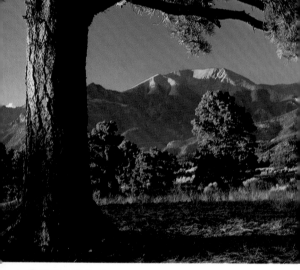

Foreground Features

A scenic picture with an empty or bland foreground is not as strong as a picture with an interesting foreground. Frame scenics with a person or object in the foreground and you'll add interest and depth. A foreground feature that contrasts in color and/or tone with distant areas is more effective in creating the illusion of depth than one that looks similar.

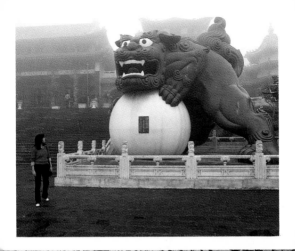

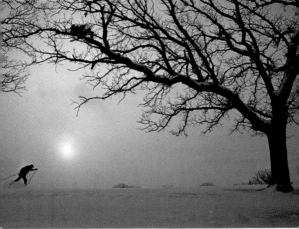

Scale

You'll never know how high the waterfall or how broad the vista in a picture unless you can compare it with an object of known size. A person standing beside the waterfall or a cross-country skier in a winter scene provides that missing information instantly and naturally. Most scenic photos benefit from a sense of scale.

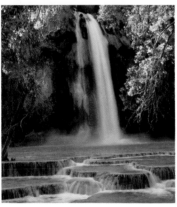

Time and Mood

If you were to photograph the same scene with the same camera and film at one-hour intervals from just before dawn until just after sundown, every picture would look different. Changes in the color, direction, and quality of light throughout the day profoundly change the appearance of such apparently changeless subjects as mountains, mesas, forests, and fjords. Whenever possible, plan to arrive at scenic spots when the light will be right in terms of illumination and mood. Early morning and late afternoon are often good times of day for scenic photographs because lighting effects change rapidly. The low angle of the sun at these times also produces a skimming light that emphasizes surface detail, adding texture to the picture. Sunset and the following twilight are moody times. Colors are very warm at sunset and very cool at twilight.

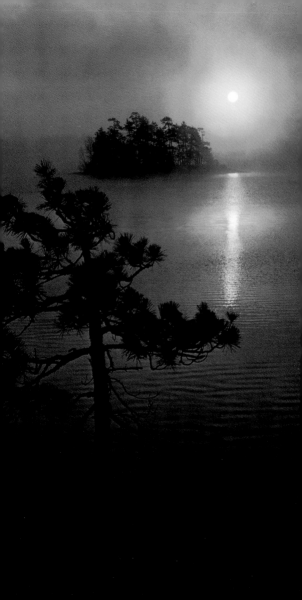

PHOTOGRAPHING ACTION

Action is exciting. Pictures of action are exciting if done right. Whether you're photographing a boy leaping onto a raft, a thoroughbred pounding down the homestretch, or an unlimited hydroplane sculpting giant rooster tails of white foam, you can increase your chances of capturing the excitement through careful preparation and anticipation.

Before the action begins, check your camera to make sure it contains live batteries and that the film is not nearly used up. If it is, insert new film so you don't miss any pictures because you were forced to reload during the action. Preset the focus, if the camera allows doing so, at the distance where significant subject motion will occur. Anticipate where and when high points are likely to occur, and be ready for them. A picture of a winning car taking the checkered flag at the finish line may be more interesting than one of the same car whistling down a straightaway. But you've got to be near the finish line to get the picture, and you've got to be there at the right time.

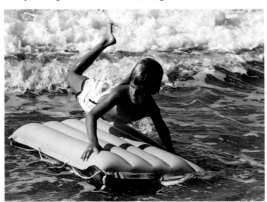

Fill the Frame

No matter how exciting the action is, it will lose impact on film if the image is too small. Pick a shooting distance that lets you fill at least one quarter to one third of the picture area with significant action. Closer is usually better, but be pru-dent. Don't approach so close that you endanger yourself or your subjects. If your camera has a built-in zoom lens or accepts interchangeable lenses, use a longer-than-normal focal length to increase image size while maintaining a safe distance from the activity.

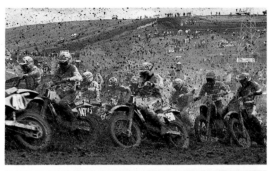

Sharp vs Blurred Action

You can depict action with sharp, crisp renditions that freeze motion or by allowing moving subjects to record with varying degrees of blur. Sharp pictures provide lots of subject detail and show dynamic form: in the top picture, see the spray of dirt frozen sharp by a fast shutter speed. Blurred pictures stress speed and movement at the expense of sharp detail. Although the dirt bikes in the top picture are certainly moving faster than the girl in the bottom picture, the girl gives a stronger sense of movement because she is slightly blurred. To stop action with 35 mm cam-

eras, use high-speed films that will allow your camera to set fast shutter speeds. If your camera cannot use high-speed films, you can stop action effectively with electronic flash when circumstances permit approaching to within flash range. To blur moving subjects, use slower films that will require longer shutter speeds (not applicable to disc cameras and some 110 cameras). As a general rule, shutter speeds of about 1/250 second and faster tend to stop action. Slower shutter speeds create increasing amounts of blur in a moving subject.

Panning

The technique called panning can give you the best of both worlds. It lets you record the moving subject relatively sharply to preserve detail, while blurring stationary elements in the field of view. Panning creates an impression of speed. Panning consists of moving the camera to hold the moving subject in a constant position in the frame during the exposure. Because most disc and 110 cameras don't have any slow shutter speeds, panning generally won't work well with them (although it might be worth trying when close to fast subjects such as galloping horses and race cars). For best results, use a 35 mm camera. Use a film slow enough to allow the camera to select relatively slow shutter speeds (1/60 second or slower) or do it on a cloudy day when the dim light causes the camera to select a slower shutter speed.

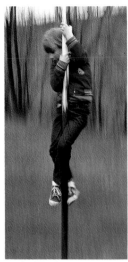

SHUTTER SPEED: 1/15 sec

HOW TO PAN

To pan, track the subject with the camera, smoothly turning your upper body as you release the shutter and keep on tracking the subject through the viewfinder. Be sure the camera is moving as you take the picture. Panning works best with subjects moving across your field of view at right angles to the lens axis. You can also pan vertically, such as in the picture of the boy sliding down a pole.

Peak Action

Trampolinists seemingly suspended in midair, and a roller coaster that has sped to the top of a rise and is about to accelerate down the far side both illustrate peak action. They represent peaks in terms of visual drama and more literally in terms of actual subject position with regard to the overall pattern of motion.

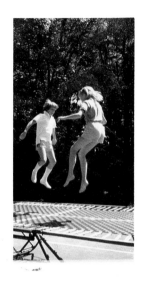

When peak action occurs, motion has slowed. Therefore you can stop it more completely during a peak than before or after. A less obvious but equally useful type of peak action in a horizontal plane occurs in motor racing and other activities. Cars must slow before entering sharp bends, and they look dramatic while cornering, so race photographers often station themselves near curves to catch the exciting, helpfully slowed-down action.

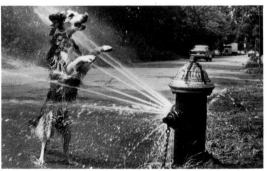

Action All Around

You don't have to wait for special events to hone your skills photographing action. The same techniques are applicable to everyday forms of subject motion. You can capture the peak action of a child on a swing, your dog battling the spray of a fire hydrant or garden hose, or the rhythmic pounding of waves crashing against the shore. Action subjects are wherever you look.

TRAVELING WITH A CAMERA

Travel invigorates the eye. Whether you're crossing the state, the country or several oceans and continents, the more you know about your ports of call the better prepared you'll be to make meaningful pictures. Consult guide books, tourist brochures and road maps to pinpoint places of interest, and plan your trip so you'll reach major attractions at times of day when you can photograph them well.

Allow plenty of time for leisurely enjoyment of what you see. Neither the trip nor the photography will be much fun if you're constantly racing the clock. Take along photo equipment and film with which you are familiar. If you want to try something new, familiarize yourself with it well in advance of departure so you'll feel comfortable and confident using it during the trip.

PHOTO EQUIPMENT AND SUPPLIES

Take two cameras if you can. It's reassuring to have a back-up. If your cameras don't have built-in flash units, take an accessory flash unit for dark interiors. Spare batteries are a must. Even if you're thoroughly familiar with your equipment, bring relevant operating manuals. Keep a lens brush, a packet of lens tissue and a small squeeze bottle of lens cleaning fluid where you can get at them. And take about twice as much film as you expect to need. You'll probably run short anyway. A compact camera bag large enough to hold your cameras, flash, cleaning materials, and a day's ration of film plus an extra roll or two will prove convenient and protect your gear from minor bumps and jolts. Carry a small notebook and pencil with your photo equipment to jot down data that will help you identify people and places when you view your pictures at home.

X-rays and Film

Airline x-ray equipment can fog unprocessed film, reducing the quality or even ruining any pictures you take on that film. The effect of x-rays is cumulative. Carry-on luggage is always x-rayed and checked luggage is often x-rayed.

Give special care to KODACOLOR VR 1000 Film: it should not be exposed to x-rays. Because of its very high speed, it should only be visually inspected. In the United States, fewer than five x-ray inspections should not visibly fog other Kodak films. But more powerful x-ray equipment used in some overseas airports can fog film during a single x-ray inspection. How can you avoid fogging from x-rays?

a. Pack film in a clear plastic bag. Carry film and loaded cameras in hand luggage, packed so it can easily and quickly be separated from other items. Arrive early at the airport and ask for a visual inspection. Stress that x-rays may damage your film. Not all inspectors will cooperate, but most will.

b. Carry KODAK Processing Mailers or other photofinisher mailers and mail film home. Film mailed in clearly marked film mailers usually is not x-rayed. If you include unprocessed film in a package, label the package "Undeveloped Photographic Film. Please Do Not X-ray."

c. If film must remain in your bag for several inspections, reorient the film each time you repack the bag so x-rays do not repeatedly penetrate it via the same path. Or reorient the bag each time it passes through x-ray inspection.

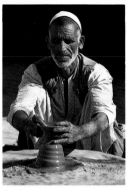

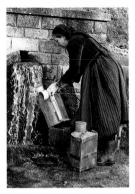

Crafts

Craftsmen and artisans making typical wares should be prime candidates for your lens. A native American silversmith or a potter from Kashmir, India, provides numerous picture possibilities. Consider making a picture series, if time permits, tracing a particular creation from raw material to finished artifact. Take lots of close-ups if you can.

Capturing Local Color

For most travelers, excitement lies in encountering differences; in people, customs, crafts and details of all sorts. Such differences are logical subjects for travel pictures. Here a Greek woman fills water cans at a local spring.

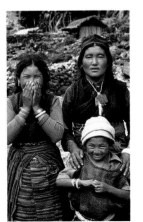

People

The people of a country are its foundation, the living expression of its customs, traditions, beliefs, and aspirations. Photograph local inhabitants unobtrusively but openly. Don't make a pest of yourself but don't skulk either. People are often flattered that you are interested enough to take a picture. When they don't wish to be photographed, as occasionally happens, give in gracefully. Their reluctance may be motivated by religious or cultural prohibitions. If, like many people, you feel shy about photographing strangers, remember that a smile is the best introduction.

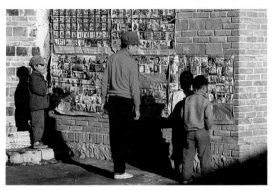

Unusual Customs

Research on the area you're visiting and on-the-scene observation will often disclose unusual customs or ways of doing things. Photograph them with respect and tact. They may be novel to you but utterly normal and conventional to local residents. This picture shows a Chinese sidewalk library. For a small fee, a customer can sit and read a pamphlet or book of his choosing but cannot leave the area with the book.

Details

As the song says, little things mean a lot. Be alert for telling details that can add interest to your travel coverage. A picture of a road sign is a visual caption identifying the locale of subsequent views. Here, close-ups of Buddha statuettes symbolize the mystique of China.

BASIC CAMERAS

Any camera that works properly can take satisfactory pictures of most popular photo subjects. You don't need lots of bells and whistles to take good pictures. Basic cameras come in a variety of types and sizes. KODAK Disc Cameras are compact, easily pocketable picture-takers that accept drop-in film discs. Each disc provides 15 color negative exposures.

Only slightly larger than disc cameras but still able to slip into a pocket with room to spare are models such as the KODAK EKTRALITE 10 Camera, which accept 110-size film cartridges. The fast-loading, drop-in film cartridges are available with 12, 20, or 24 exposures, depending on film type. Black-and-white and color slide films are available in 110-size cartridges in addition to medium- and high-speed color negative materials. Not all 110 cameras can use color slide film (check your manual).

Instant cameras provide a finished print within minutes after the picture was taken. They tend to be fixed- or auto-focus cameras and often have the option of a built-in close-focusing lens.

35 mm cameras are the fourth major category of basic cameras. An extremely broad range of film types in black-and-white negative, color slide, and color negative is available for 35 mm cameras, suited for both general-purpose and specialized applications.

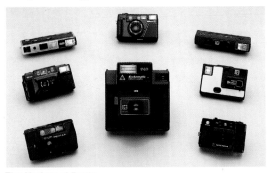

The Variety of Basic Cameras

There is a great variety of basic cameras to choose from.

Shown here are 110, disc, instant, and autofocus 35 mm cameras.

SMALL LENS OPENING
IN BRIGHT LIGHT

LARGE LENS OPENING
IN DIM LIGHT

LIGHT-MEASURING
PHOTOCELL

Exposure Control

Nearly all modern basic cameras adjust exposure automatically to suit the brightness of the scene. In bright light, they use a smaller lens opening and/or a faster shutter speed. In dim light, to let in more light, they use a larger lens opening and/or a slower shutter speed. Most popular models also provide automatic exposure control for flash photography. Some basic 35 mm cameras permit manual exposure control for special effects, difficult lighting situations, or simply when you want to do something other than what the camera would like to do.

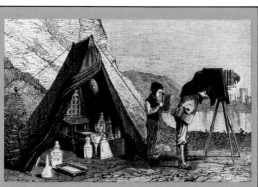

MORE THAN A CENTURY AGO

In the mid-1800's, a day of picture-taking was a major undertaking. Over a hundred pounds of camera gear was required. Included were glass plates and chemicals to coat the plates with a film emulsion, chemicals for development, a large camera and supporting tripod, and a tent to serve as darkroom—and a porter to carry all the stuff. Nowadays you sling a camera over your shoulder and off you go.

Read Instructions Carefully

The operating instructions supplied with cameras and other photo equipment are guides to obtaining the best possible results. With new equipment, read the owner's manual before you start pushing buttons, moving levers or opening access doors or covers. With familiar gear, review the operating instructions periodically as a refresher course. Always check the data printed on or enclosed in film boxes to be sure you've actually got the type of film you want. And even if you always use the same type of film, remember that specifications can change as improvements are made. The film data will alert you to any that may require changes in the way you use the product.

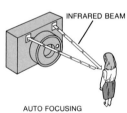

INFRARED BEAM

AUTO FOCUSING

SYMBOL FOCUSING

Focusing

The simplest cameras have fixed-focus lenses that are factory set to make acceptably sharp pictures of subjects at moderate to great distances (4 ft [1.2 m] to infinity). Cameras that allow you to set the lens manually for distance with reference to a footage scale or symbolic distance indicators are more versatile. They normally allow sharp pictures to be made at camera-to-subject distances from about 3 feet (0.9 metre) to infinity. Some models also have special close-up settings that are useful for making large images of relatively small subjects. Automatic focusing cameras often work by bouncing an infrared beam off the subject to determine the subject's distance. Built-in optical rangefinders allow setting focus manually with speed and precision, as do the reflex-viewing systems of many advanced-model 35 mm cameras. Focus as carefully as your camera's design permits. Proper focus is vital to sharpness.

BASIC MAINTENANCE

The best maintenance you can give your photographic equipment is the simplest: Keep it clean. Clean lenses make sharper pictures than dirty ones, so check the front and rear surfaces occasionally. When necessary, remove loose dust with a bulb-type blower or a soft lens brush. Fingerprints or clinging particles can be removed with KODAK Lens Cleaner and KODAK Lens Cleaning Paper. Apply the fluid to the cleaning paper. Never flood the lens surface with liquid. Wipe dust from the camera exterior with a clean, soft cloth. Always remove external sand or grit after outings at the beach. Don't open the camera to change film when wind is blowing dust or sand. Do it in a sheltered place or with the camera shielded with a bag. Every now and then use a bulb-type blower to remove accumulated grit, if any, from the interior of the camera. Be sure you blow particles out of the camera, not farther inside. Check battery

condition before taking pictures and replace old batteries with fresh ones to give proper camera and/or flash operation. When putting equipment away for extended periods of time, remove batteries and store them separately. If a camera control ever offers unusual resistance, stop immediately. Review the owner's manual to make sure you're following correct operating procedures. If the problem persists, take or send the camera to an authorized repair station. Never force anything that seems stuck. If you do, you may turn a small problem into a big one.

Proper Photo Stance

When standing, place your feet about 18 to 24 inches (45 to 61 cm) apart to form a stable base. Hold your arms close to your body, with the upper arms resting against your chest. Press the camera body lightly against your face. Form a compact, cohesive unit in which you and your camera become one.

FILM

The type of film to use depends on availability and suitability. Clearly, you cannot use any film that is not available in a size that fits your camera, and not all films are made in all sizes. Assuming that you can exercise some choice, the following film facts and recommendations will help you make sensible selections.

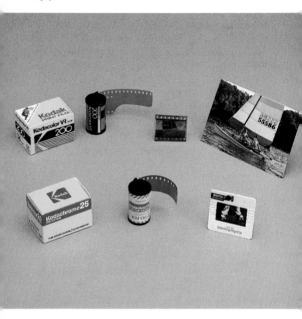

Slides and Prints

There are two basic types of general-purpose photographic film: slide (transparency) films, which yield positive images that you project or view by transmitted light; and negative, or print films, which yield negative images from which positive prints are made in an additional step. With slide films, the film exposed in the camera becomes the finished picture.

With print films, the film exposed in the camera becomes a negative that is used in turn to make a finished print. In fact, it is possible to make prints from slides and to make slides from negatives, but these are secondary applications. For optimum picture quality, pick a transparency film if you want slides and use a negative film if you are primarily interested in making prints.

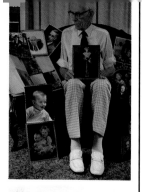

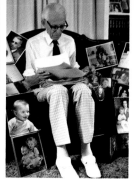

OUTDOOR SLIDE FILM
(Daylight Balanced)

INDOOR SLIDE FILM
(Tungsten Balanced)

Color and Black-and-White

Films are further differentiated according to whether they produce pictures in color or in black and white. Negative color films are intended for making color prints and are in practical terms universal films. That is, you can expose them indoors or outdoors, by nearly any common light source, and obtain acceptable color rendition. Color slide films are available in both daylight and indoor, or tungsten versions. Daylight films produce realistic color rendition in daylight and with electronic flash or blue flashbulbs, both of which are similar to daylight in color quality. Indoor-type slide films produce realistic color rendition when exposed by incandescent lamps such as household light bulbs, studio lamps, and photofloods. Outdoor slide films may be used indoors and indoor slide films may be used outdoors with appropriate filters, but this practice is less desirable than matching the film type to the light source. Black-and-white film is negative film intended for making black-and-white prints. Although you can make black-and-white prints from color negatives and slides, you cannot photographically produce color prints or slides from a black-and-white negative. When you want the rich, dramatic tonality of a black-and-white image, select a black-and-white film.

Film Speed

Film speed is a measure of a film's sensitivity to light. Film speed is of prime interest to those with 35 mm cameras, because of the large number of films in a variety of speeds available for these cameras. A film's speed is expressed as an ISO number or speed number. The higher the number the greater the sensitivity. A film rated at ISO 400 is twice as sensitive to light as one rated at ISO 200.

General-purpose Kodak films range in speed from ISO 25 to ISO 1000. (Slower and faster films are available for specialized applications.) Films with speeds of ISO 25 to ISO 200 are amply fast for all-around photography in bright light. For action photography outdoors, ISO 200 and ISO 400 films allow cameras to set action-stopping shutter speeds. In subdued light and indoors without flash, use films with ISO speeds of 400 or higher, if your camera can accommodate them. For flash photography, consult the owner's manual to determine compatible film speeds.

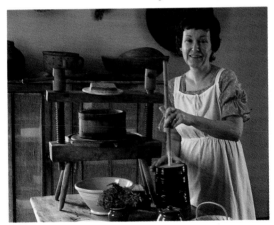

KODACOLOR VR 200 and VR 400 Films

These two color negative films offer a favorable combination of image quality and speed that makes them good general-purpose films. Easily used in bright light, they are also fast enough for many dim-light situations. And they are sharp enough to give good enlargements. KODACOLOR VR 200 Film is available in 110, 126, and 35 mm sizes. KODACOLOR VR 400 Film is available in 110 and 35 mm sizes. This picture was taken on KODACOLOR VR 400 Film.

KODACOLOR VR 100 FILM:
MAGNIFIED 15 X

KODACOLOR VR 1000 FILM:
MAGNIFIED 15 X

Graininess

If you examine any processed film under sufficiently high magnification, you will notice a granular texture that is part of the image rather than a characteristic of the subject. This graininess varies fairly predictably within a given film family in relation to film speed. The faster the film, the greater the graininess. In prints, graininess is rarely obtrusive in enlargements of 5 x 7 inches (13 x 18 cm) or smaller, regardless of the type of film. As print size increases, so will the impression of graininess. Graininess is seldom objectionable when color slides are projected in a darkened room with viewers at normal distances from the screen. If you wish to make extremely large prints or project images

on a grand scale, use fine-grain films with ISO speeds between 25 and 200 to minimize graininess, unless the need to stop action or photograph in dim light overrides that concern. Given the same print size and the same film, graininess will be more apparent in prints made from small negatives than in prints made from larger negatives, because the latter require less enlargement. As a practical matter, if you wish to make large-size images most of the time, you'll be happier with a 35 mm camera than with one that uses a smaller format. If you don't expect to make big prints regularly, you will be well served with a compact camera that uses disc or 110-size film.

Brightness of Light

FILM SELECTION CHART

Sunny Day

Color Print

B&W Print

Color Slide

Overcast Day

Color Print

B&W Print

Color Slide

Dim Light
(Indoors and out)

Color Print

B&W Print

Color Slide

▢▪ Disc	📷 110	📷 35 mm
	Type of Film	
KODACOLOR VR Disc	KODACOLOR VR	KODACOLOR VR 100 KODACOLOR VR 200 For fast action use KODACOLOR VR 400.
none available	VERICHROME Pan	PANATOMIC-X PLUS-X For fast action use TRI-X Pan.
none available	EKTACHROME 64*	EKTACHROME 100 KODACHROME 25 or 64 For fast action use EKTACHROME 200 or 400.
KODACOLOR VR Disc	KODACOLOR VR KODACOLOR VR 400	KODACOLOR VR 200 KODACOLOR VR 400 For fast action use KODACOLOR VR 1000.
none available	VERICHROME Pan	PLUS-X Pan TRI-X Pan
none available	EKTACHROME 64*	KODACHROME 64 EKTACHROME 100 EKTACHROME 200 EKTACHROME 400
KODACOLOR VR Disc (with flash in very dim light)	KODACOLOR VR 400 (with flash in very dim light)	KODACOLOR VR 400 KODACOLOR VR 1000
none available	VERICHROME Pan (with flash)	TRI-X 400
none available	EKTACHROME 64* (with flash only)	EKTACHROME 400

*Check your camera manual to see if your 110 camera works with EKTACHROME 64 Film.

105

ADVANCED CAMERAS FOR GREATER IMAGE CONTROL

As your interest in photography grows, you will encounter situations that make you wish for more control over the photographic process than a basic camera permits. Single-lens reflex (SLR) and rangefinder cameras that accept interchangeable lenses offer additional opportunities for image control. SLR cameras let you view and focus an image actually formed by the lens that takes the picture and can usually accept an extremely broad spectrum of lenses and other optical accessories. Interchangeable-lens rangefinder cameras offer quick, precise focusing with an internally coupled rangefinder that is visible in the optical viewfinder through which you compose. They accept fewer lenses and accessories than do most SLRs, but offer brighter viewing and focusing, an advantage in dim light.

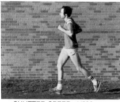
SHUTTER SPEED: 1/500 sec

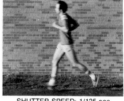
SHUTTER SPEED: 1/125 sec

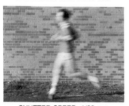
SHUTTER SPEED: 1/30 sec

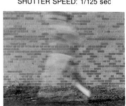
SHUTTER SPEED: 1/8 sec

Controlling Shutter Speed

Advanced cameras allow you to select specific shutter speeds or shutter-speed ranges. You can choose high shutter speeds such as 1/500 or 1/1000 second or faster with some cameras to freeze action. Or you can pick relatively slow speeds such as 1/30, 1/15, or 1/8 second to blur motion. Disc and 110

cameras typically have one or two set shutter speeds (selected by the camera) somewhere between 1/60 and 1/200 second. Most advanced cameras also permit keeping the shutter open for extended periods of time when you want to make long exposures in very dim light with a tripod-mounted camera.

APERTURE RING

LARGE APERTURE: f/2.8

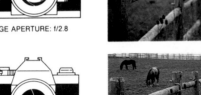

SMALL APERTURE: f/22

Controlling Depth of Field

Depth of field is the near-to-far area that appears sharp in the photograph in addition to the subject. An adjustable diaphragm in the lens helps control depth of field. It can open and close much like the pupil of the eye. On some simple cameras, the diaphragm is fixed at one opening. On others, the diaphragm opening is adjustable but only the camera can change it. With most SLR cameras, you can set the lens opening (aperture) to the size you want. Small apertures maximize depth of field; larger apertures reduce it. A camera that allows you to adjust the aperture thus allows you to control sharpness in depth in the photograph. Most SLR cameras let you judge sharpness in depth visually in the viewfinder. Rangefinder cameras indicate the extent of sharpness numerically in feet or metres on a depth-of-field scale. The ability to minimize the zone of sharpness allows you to direct the viewer's gaze and attention within the picture.

Interchangeable Lenses

Basic cameras are equipped with noninterchangeable lenses characterized as normal or slightly wide-angle. Normal lenses include a field of view that corresponds approximately to that experienced with normal human vision. Wide-angle lenses take in more of a scene from a given distance. Normal and slightly wide-angle lenses are useful for most general picture-taking. Advanced cameras can accept interchangeable lenses ranging from extreme wide-angles to extreme telephotos, in addition to the normal optics with which they are often equipped when purchased. Nearly all SLR cameras can also be fitted with zoom lenses, which have adjustable fields of view that you can make wider or narrower by moving a control on the lens.

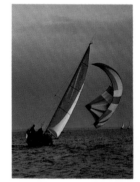

Telephoto Lenses
Telephoto lenses let you make bigger images of the subject on film without having to move closer. Compared to a normal camera lens on a 35 mm camera, a 100 mm telephoto lens magnifies the image 2X. A 200 mm telephoto lens magnifies the image 4X. Telephoto lenses are especially useful for portraiture, action, and wildlife photography.

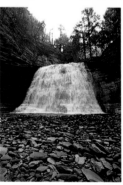

Wide-Angle Lenses
Wide-angles let you take in more of a scene from a given distance than you could with a normal lens. They spare you the need to move back when it's inconvenient or impossible. They also allow you to move in close to exaggerate subject size relative to other scene elements.

35-135 mm ZOOM LENS

ONE ZOOM LENS CAN
REPLACE SEVERAL
SINGLE-FOCAL LENGTH LENSES

At 35 mm

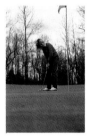

At 85 mm

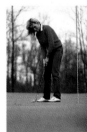

At 135 mm

Zoom Lenses

With a zoom lens, you can stand in one spot and change the image size of the subject and the amount of surroundings included. Without moving, you can go from a full figure shot to a head-and-shoulders portrait, or anything in-between. For general-purpose photography, the most useful zoom lenses are those that can function as wide-angle, normal, and telephoto lenses. Like all zoom lenses, these are designated by their focal length range in millimetres. Typical wide-angle to telephoto zooms have focal length ranges of 35-105, 35-135, and 35-200 mm. Other zoom lenses can function as several wide-angle lenses or several telephoto lenses. A 24-50 mm lens is typical of a wide-angle zoom lens. An 80-200 mm lens is typical of a telephoto zoom lens. Zoom lenses are handy for travel and action photography because their adjustable fields of view let one lens replace several conventional lenses. Zoom lenses tend to be slightly larger and heavier than conventional lenses, usually have less light-gathering ability, and cost a bit more. They are not usually good choices for low-light photography.

MACRO LENS

EXTENSION TUBES

SUPPLEMENTARY
CLOSE-UP LENSES

BELLOWS

Macro Lenses and Close-Up Equipment

If you want to make close-ups of small subjects, advanced cameras can satisfy you with macro lenses and other close-up equipment. Macro lenses are like normal or telephoto lenses, but they are specially corrected to produce fine im-ages at close distances and can focus very close without special attachments. Close-up accessories such as extension tubes, bellows units, and supplementary lenses allow close-up photography with the conventional lenses you already have, although slightly less conveniently.

USING YOUR PICTURES

By far the most popular use of photographs is in the photo album, where one can scan page after page of a family history and see how the kids have grown up, fondly recall your first house, or shake your head over how the new car you were once so proud of now seems ancient. The photo album has become a treasured tradition in many families. Yet you can do more with pictures than to place them in a photo album that you view only a few times each year. If you're interested in any of the ideas presented below, discuss them with your photo dealer to learn more about them.

Greeting Cards

To truly greet friends and relatives, the expression should come from you. And it will when you use one of your photographs to carry your message of goodwill. You may choose an outdoor scenic that reflects the Christmas season or you may want to use a picture of your family. Along with your picture, a message will be printed on the card. Together they provide a personal touch and make your greetings more sincere. You can also order photo cards for birth announcements and "Thank-You's."

Poster Prints

With your favorite pictures, the ones that came out really well, you may decide to order enlargements, then frame and hang them on the wall, or set them atop a desk. Why not do more? Now you can give those special pictures special treatment at a price that may surprise you. Kodak offers Poster Prints. They are 20 x 30-inch enlargements that show how impressive a good picture can be when scaled up to dramatic proportions. Poster prints are made only from 35 mm negatives or slides. (Cropping is not available.)